ED EMBERLEY'S DRAWING BOOK of FACES

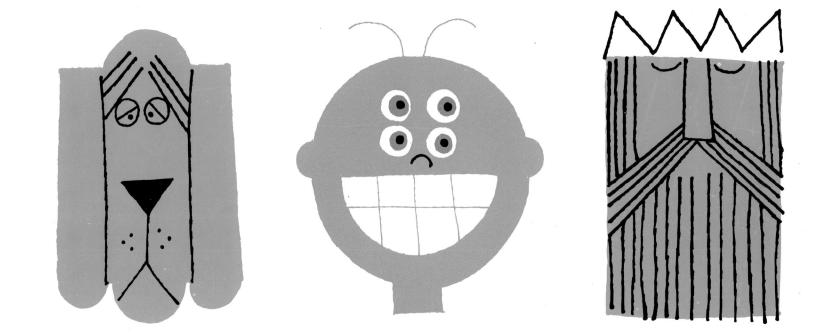

LITTLE, BROWN & COMPANY BOSTON - TORONTO - LONDON

Other books by Ed Emberley:

Ed Emberley's Christmas Drawing Book

Ed Emberley's Drawing Book: Make a World

Ed Emberley's Drawing Box

Ed Emberley's Thumbprint Drawing Box

The Wing on a Flea

First Paperback Edition

Library of Congress Cataloging-in-Publication Data
Emberley, Ed.
 Ed Emberley's drawing book of faces / Ed Emberley.
 p. cm.
 Includes index.
 Summary: Simple step-by-step instructions for drawing a wide variety of faces reflecting various emotions and professions.
 ISBN 0-316-23609-8 (hc)
 ISBN 0-316-23655-1 (pb)
 1. Face in art. 2. Drawing — Technique. [1. Drawing — Technique.]
I. Title. II. Title: Drawing book of faces.
NC770.E42 734'.49 74-32033

10 9 8 7 6 5 4 3 2 1

WOR

Published simultaneously in Canada
by Little, Brown & Company (Canada) Limited

Printed in the United States of America

2

IF YOU CAN DRAW THESE THINGS → •∪DO△□ ⅇⅇⅇⅇ
YOU CAN DRAW ALL KINDS OF FACES.
EASY STEP-BY-STEP DRAWINGS SHOW YOU HOW.
THIS ROW SHOWS WHAT TO DRAW.
THIS ROW SHOWS WHERE TO PUT IT.

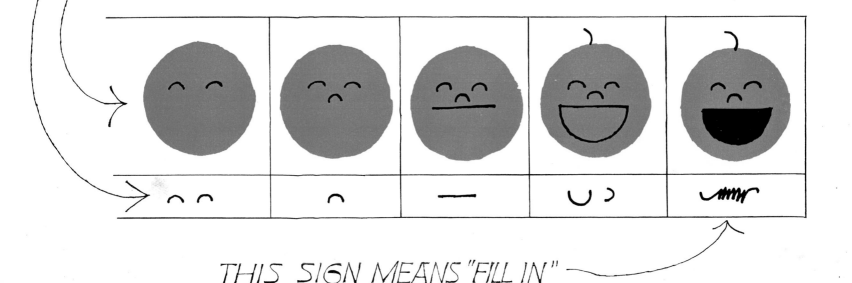

THIS SIGN MEANS "FILL IN"

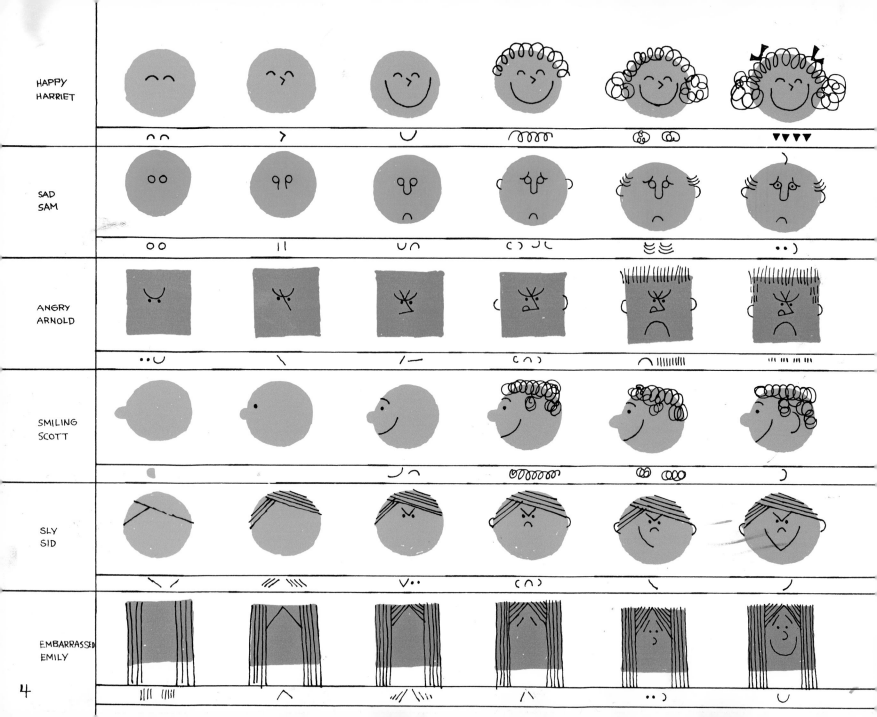

HAPPY
HARRIET

SAD
SAM

ANGRY
ARNOLD

SMILING
SCOTT

SLY
SID

EMBARRASSED
EMILY

4

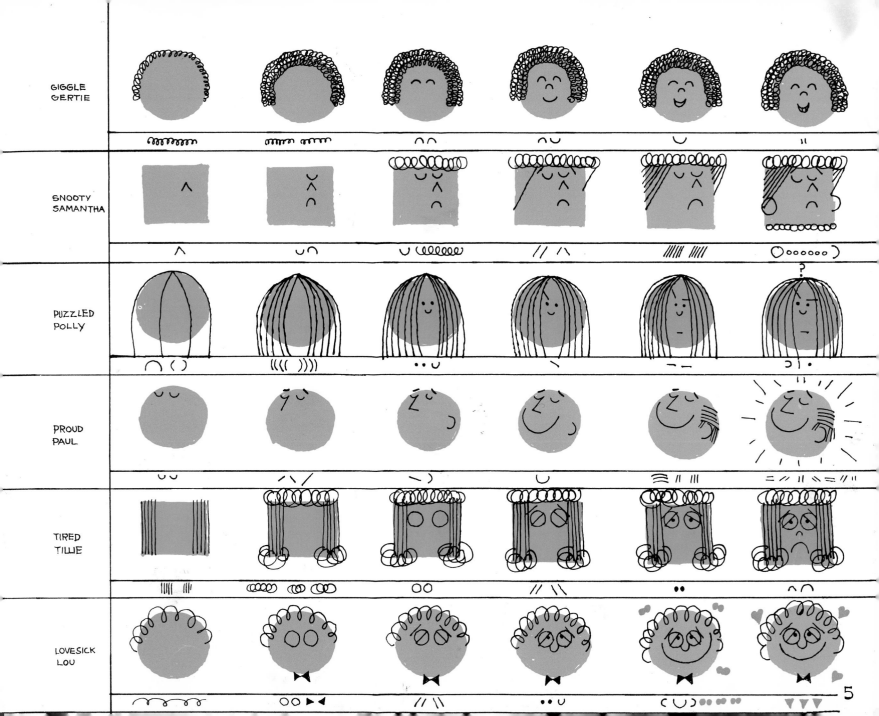

GIGGLE GERTIE

SNOOTY SAMANTHA

PUZZLED POLLY

PROUD PAUL

TIRED TILLIE

LOVESICK LOU

5

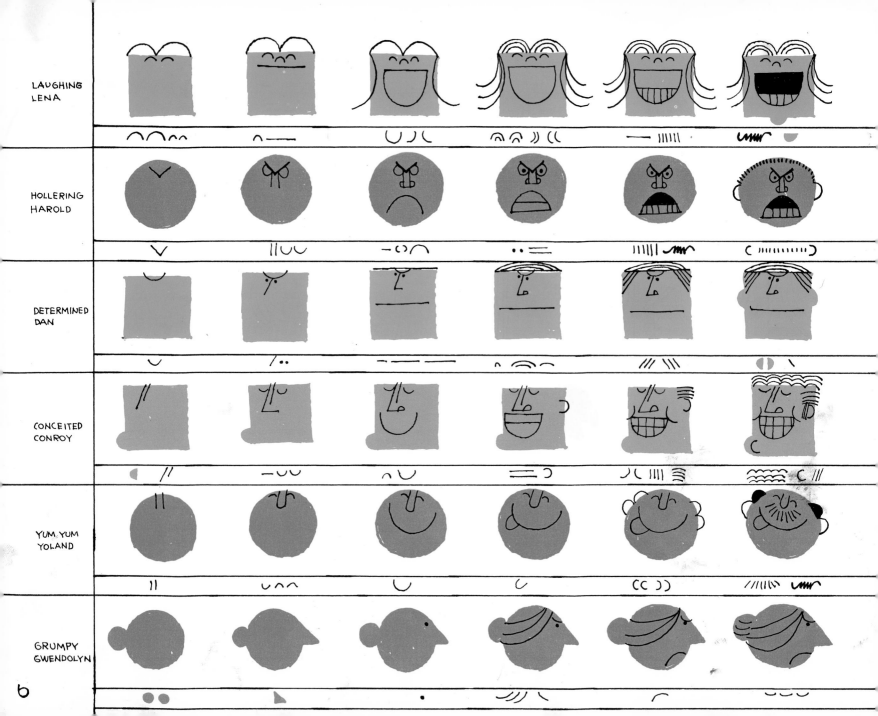

LAUGHING LENA

HOLLERING HAROLD

DETERMINED DAN

CONCEITED CONROY

YUM YUM YOLAND

GRUMPY GWENDOLYN

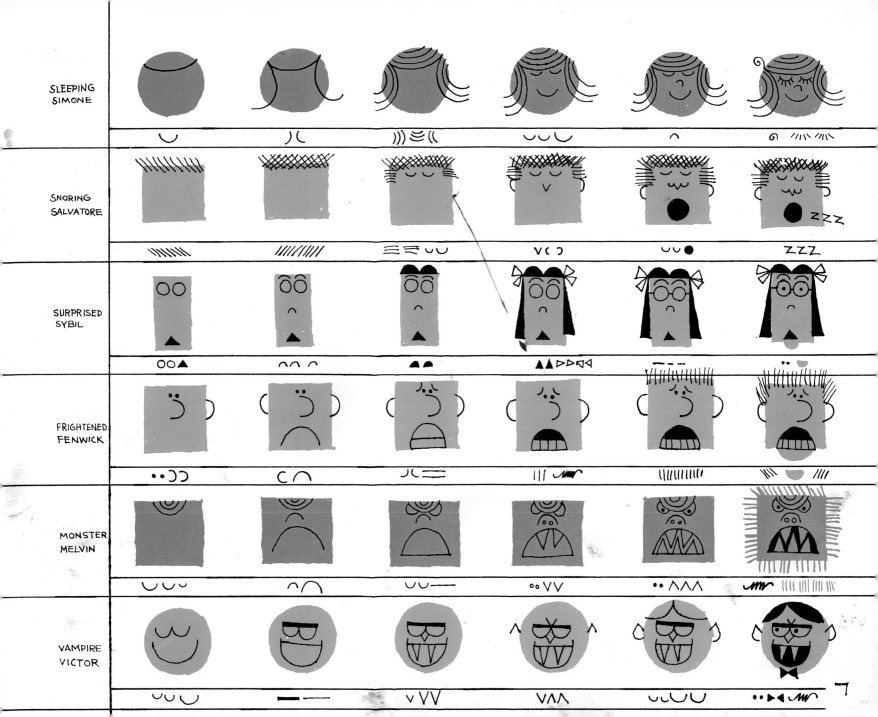

SLEEPING SIMONE						
SNORING SALVATORE						
SURPRISED SYBIL						
FRIGHTENED FENWICK						
MONSTER MELVIN						
VAMPIRE VICTOR						

7

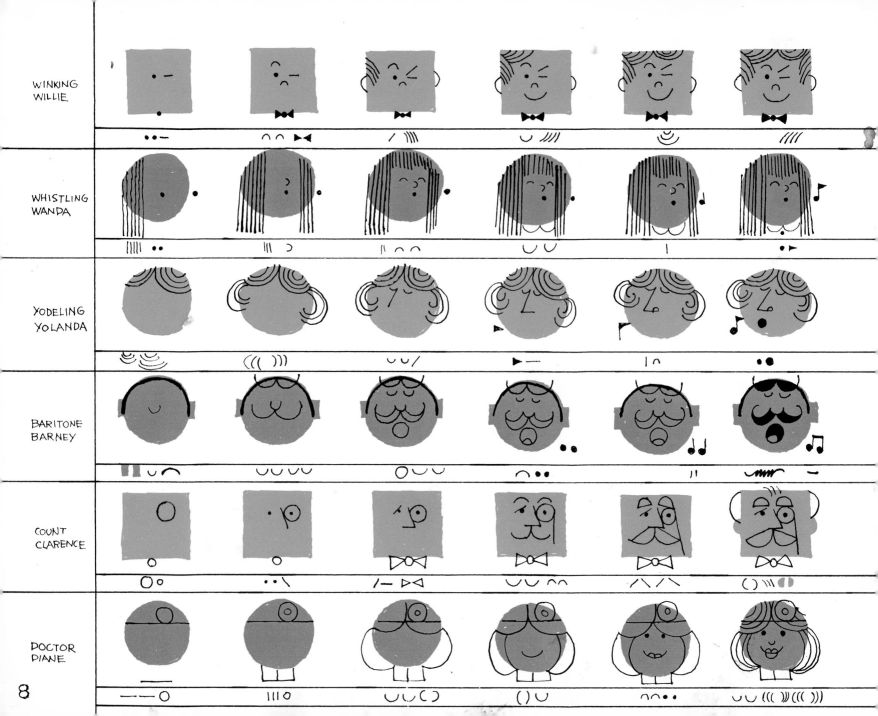

WINKING
WILLIE

WHISTLING
WANDA

YODELING
YOLANDA

BARITONE
BARNEY

COUNT
CLARENCE

DOCTOR
DIANE

8

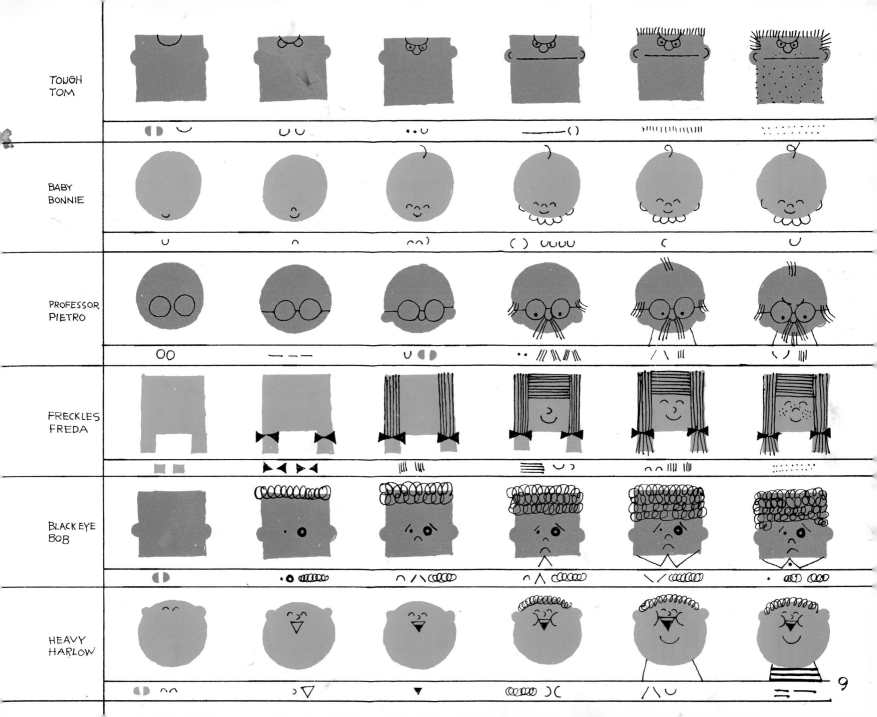

TOUGH TOM

BABY BONNIE

PROFESSOR PIETRO

FRECKLES FREDA

BLACK EYE BOB

HEAVY HARLOW

9

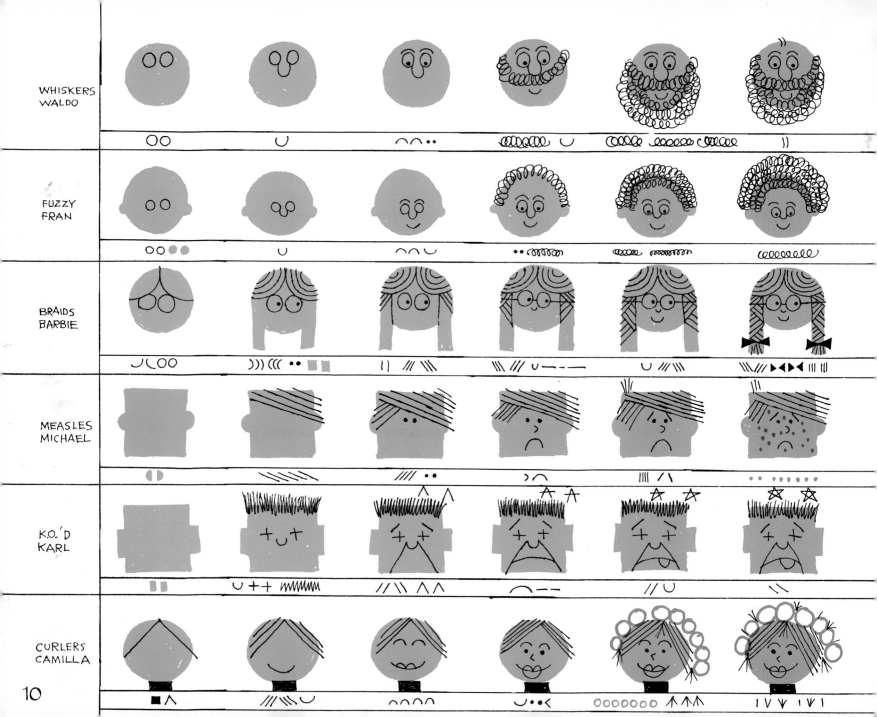

WHISKERS
WALDO

FUZZY
FRAN

BRAIDS
BARBIE

MEASLES
MICHAEL

K.O.'D
KARL

CURLERS
CAMILLA

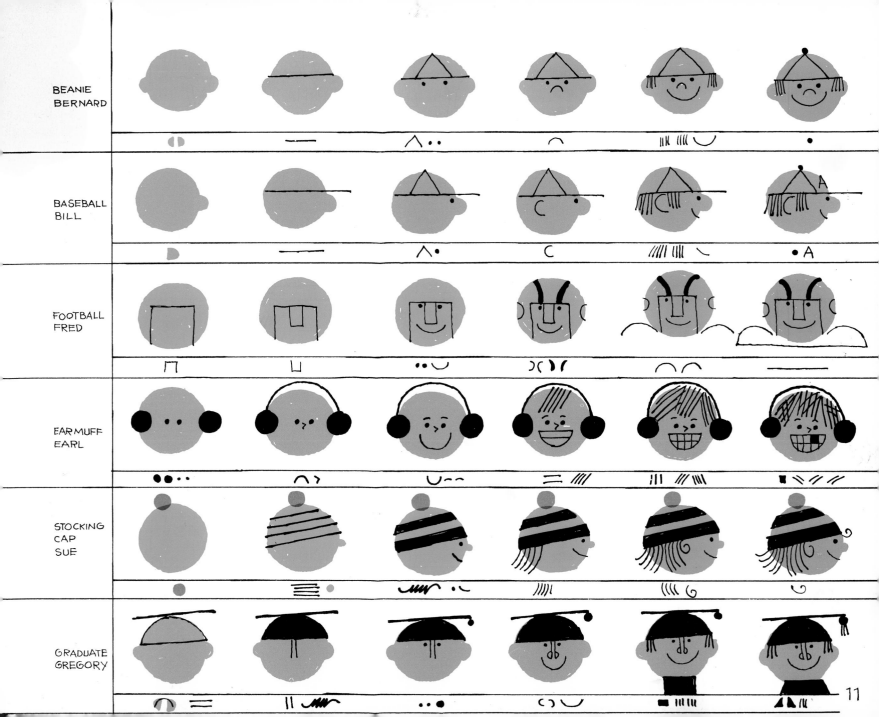

BEANIE
BERNARD

BASEBALL
BILL

FOOTBALL
FRED

EARMUFF
EARL

STOCKING
CAP
SUE

GRADUATE
GREGORY

11

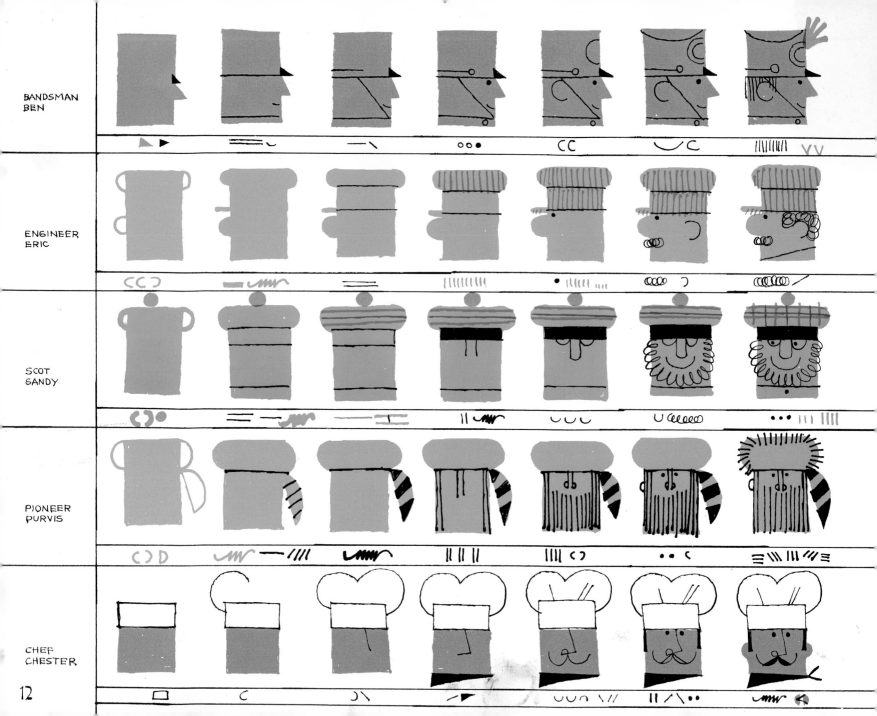

BANDSMAN BEN

ENGINEER ERIC

SCOT SANDY

PIONEER PURVIS

CHEF CHESTER

12

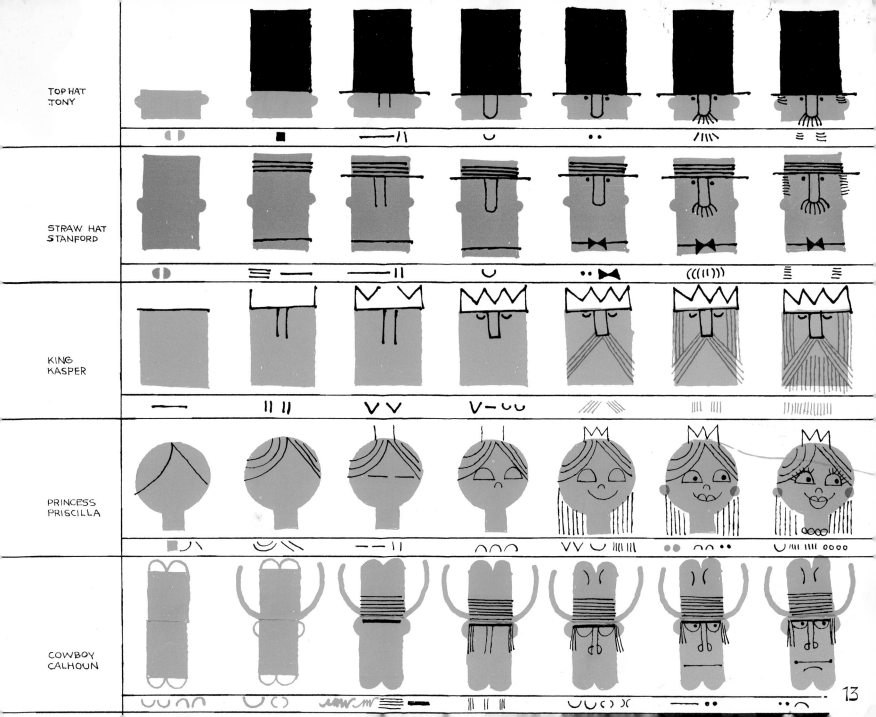

TOP HAT TONY

STRAW HAT STANFORD

KING KASPER

PRINCESS PRISCILLA

COWBOY CALHOUN

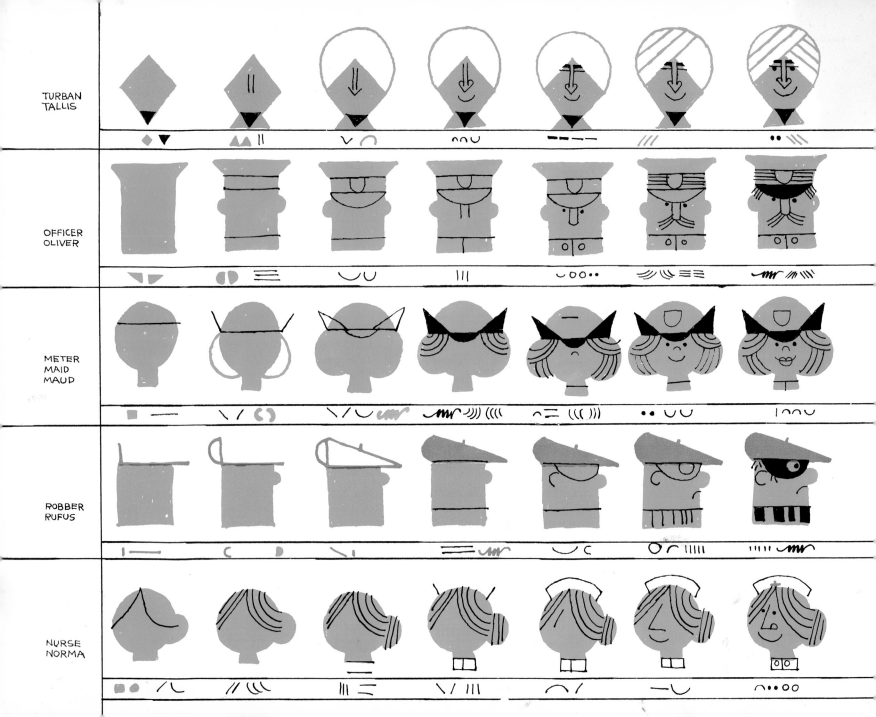

TURBAN
TALLIS

OFFICER
OLIVER

METER
MAID
MAUD

ROBBER
RUFUS

NURSE
NORMA

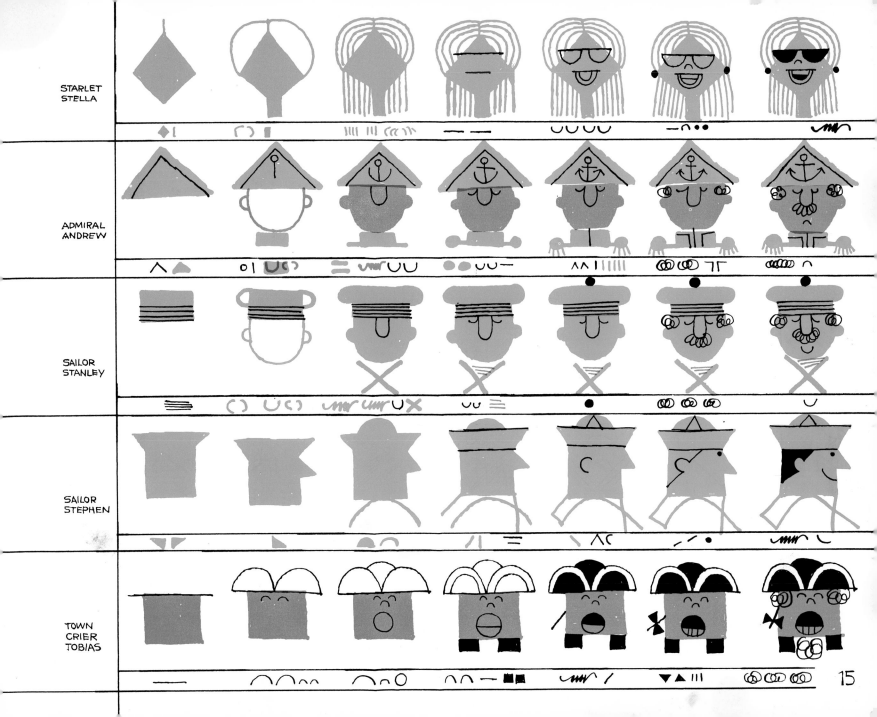

STARLET
STELLA

ADMIRAL
ANDREW

SAILOR
STANLEY

SAILOR
STEPHEN

TOWN
CRIER
TOBIAS

15

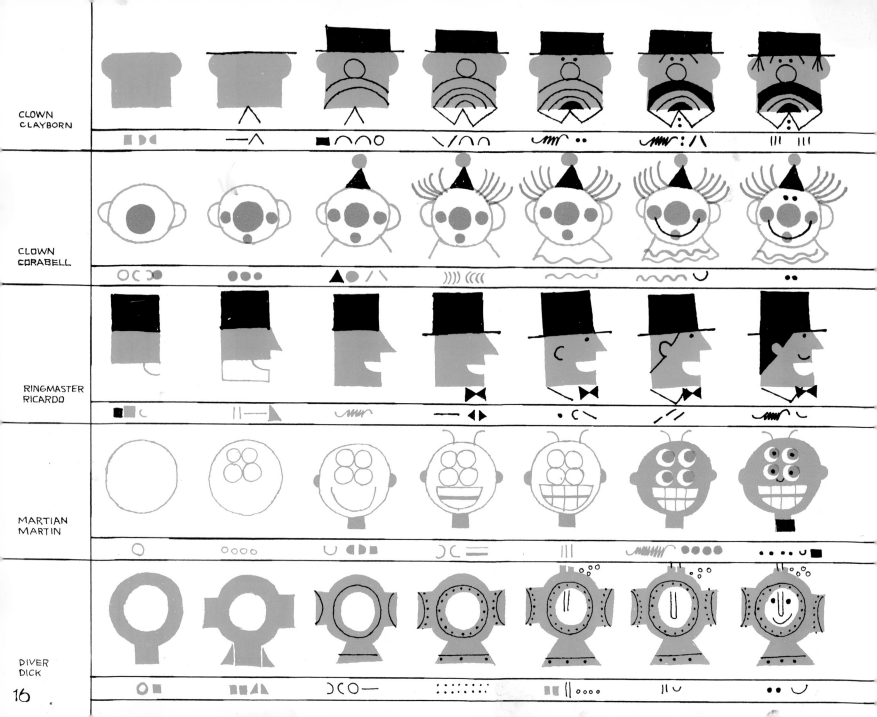

CLOWN
CLAYBORN

CLOWN
CORABELL

RINGMASTER
RICARDO

MARTIAN
MARTIN

DIVER
DICK

16

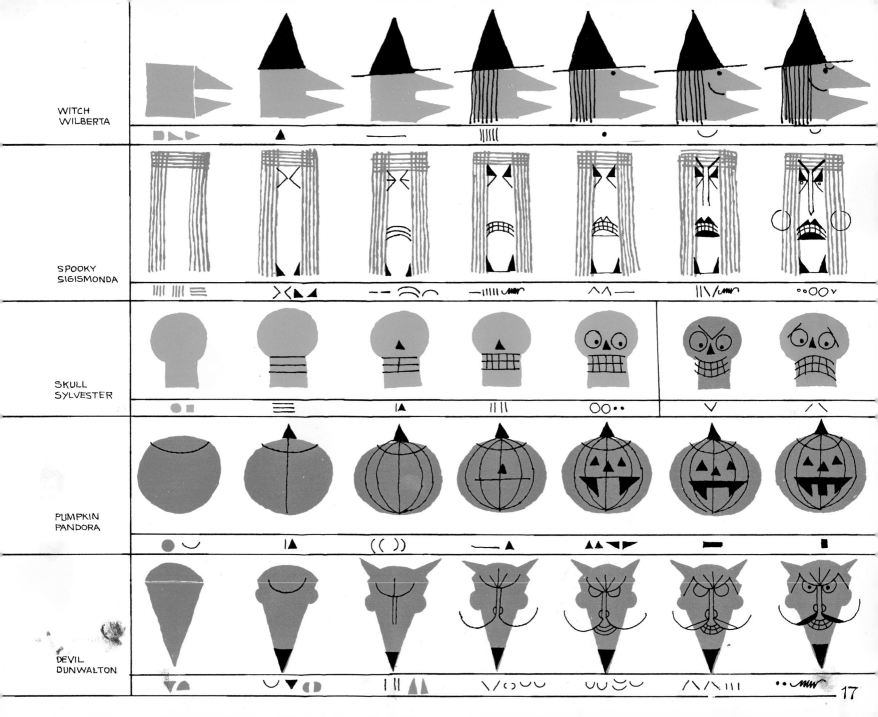

WITCH
WILBERTA

SPOOKY
SIGISMONDA

SKULL
SYLVESTER

PUMPKIN
PANDORA

DEVIL
DUNWALTON

17

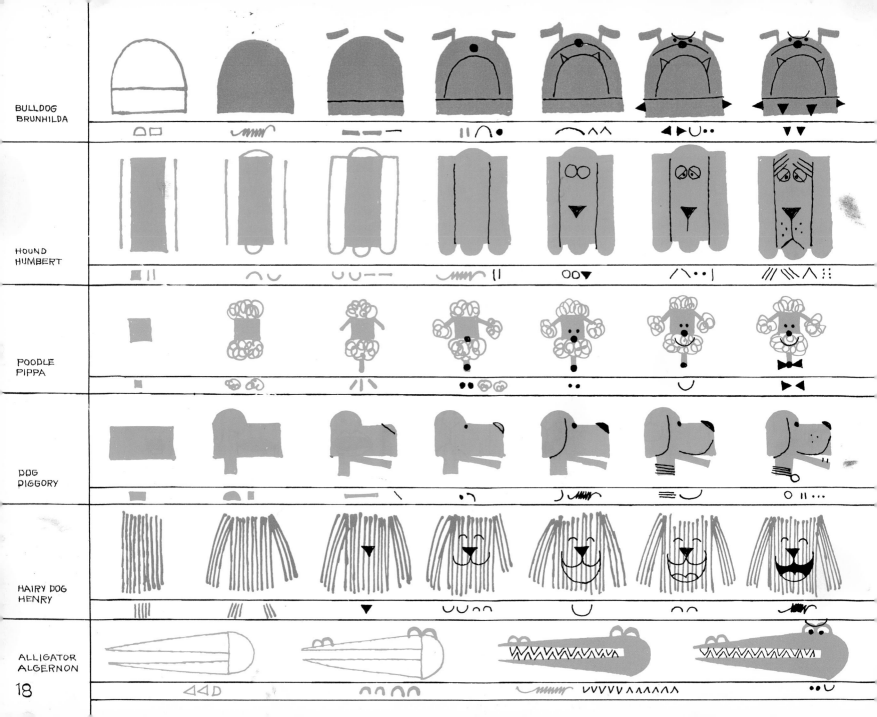

BULLDOG
BRUNHILDA

HOUND
HUMBERT

POODLE
PIPPA

DOG
DIGGORY

HAIRY DOG
HENRY

ALLIGATOR
ALGERNON

18

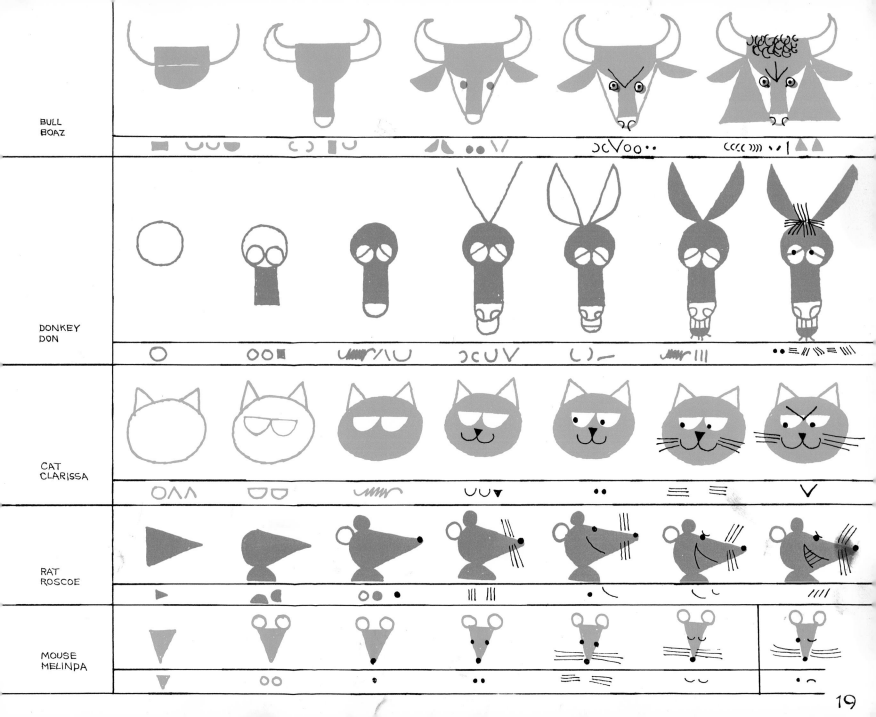

BULL
BOAZ

DONKEY
DON

CAT
CLARISSA

RAT
ROSCOE

MOUSE
MELINDA

19

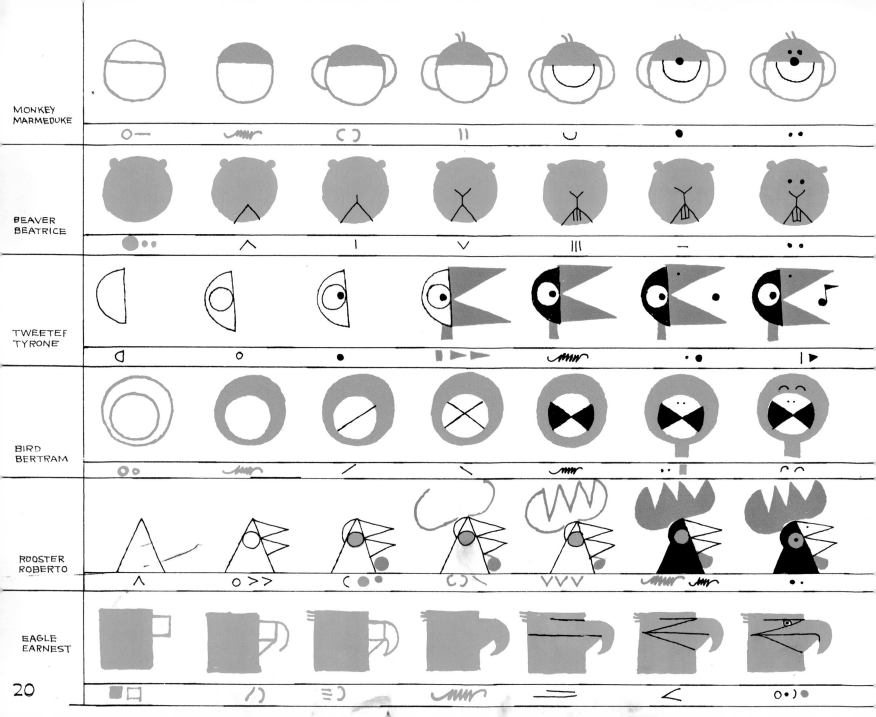

MONKEY
MARMEDUKE

BEAVER
BEATRICE

TWEETER
TYRONE

BIRD
BERTRAM

ROOSTER
ROBERTO

EAGLE
EARNEST

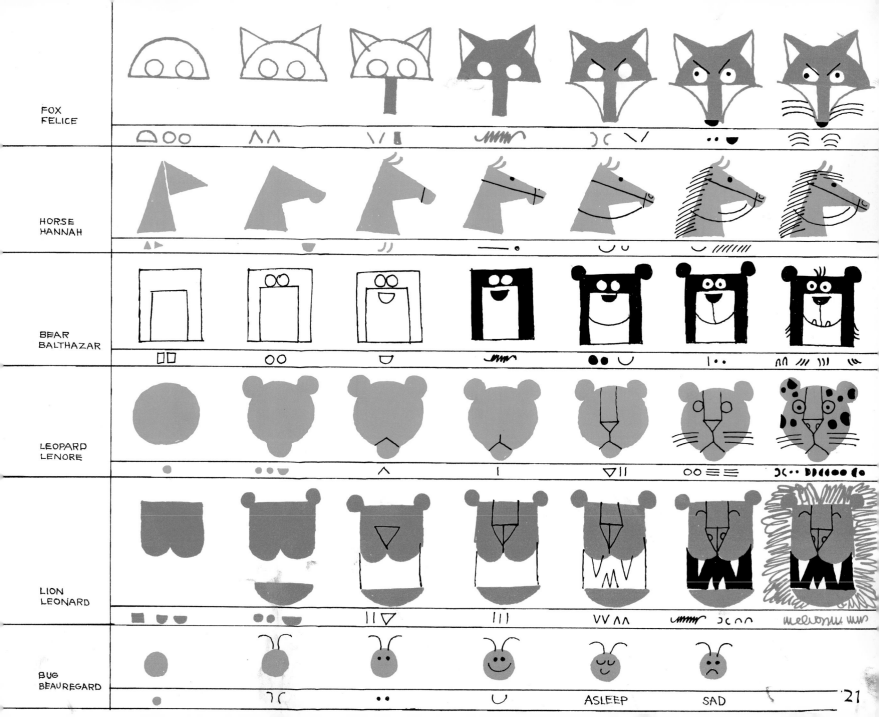

FOX
FELICE

HORSE
HANNAH

BEAR
BALTHAZAR

LEOPARD
LENORE

LION
LEONARD

BUG
BEAUREGARD

ASLEEP SAD

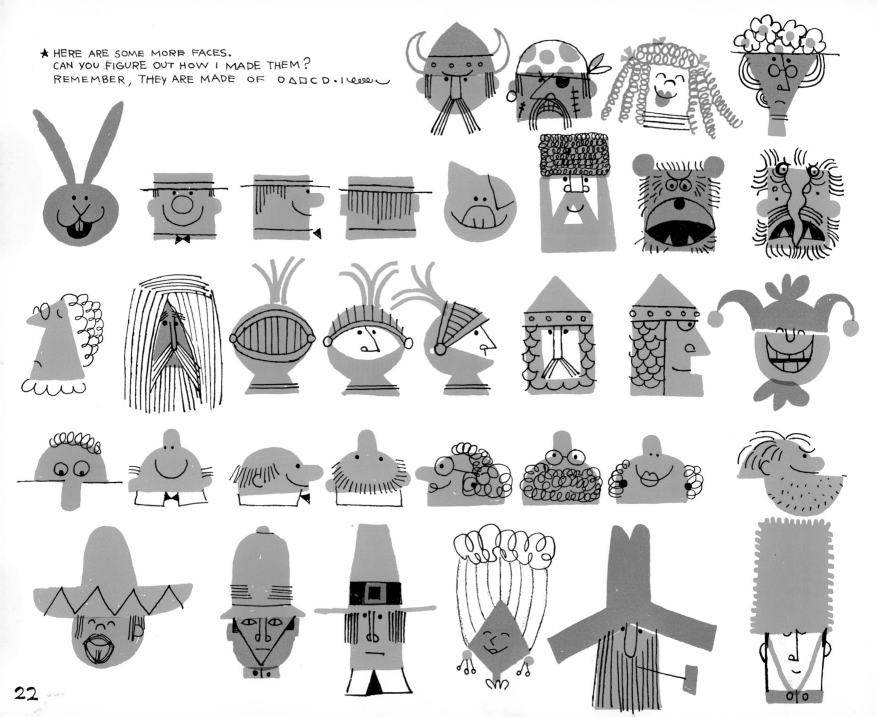

★ HERE ARE SOME MORE FACES.
CAN YOU FIGURE OUT HOW I MADE THEM?
REMEMBER, THEY ARE MADE OF ○△□CD·l ͔͔͔͔

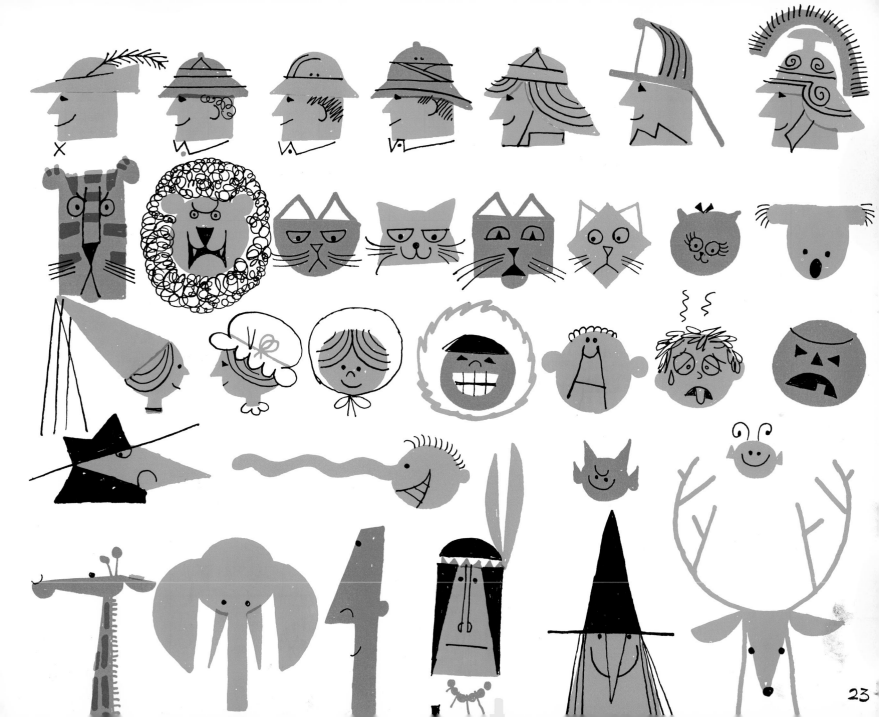

23

- ONE PART OF LEARNING TO DRAW IS TO LOOK AT REAL THINGS, PHOTOGRAPHS OF THINGS AND OTHER ARTISTS' WAYS OF DRAWING THINGS AND TRY TO DRAW WHAT YOU SEE. ANOTHER PART IS TO TAKE PIECES OF TWO OR MORE THINGS YOU LEARN TO DRAW AND PUT THEM TOGETHER TO MAKE A NEW THING. HERE ARE SOME WAYS FOR YOU TO MAKE "NEW THINGS" WITH THIS BOOK.

★ YOU CAN MAKE THE SHAPE TALLER... ...WIDER...OR...

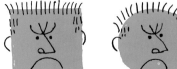 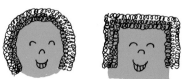

CHANGE IT... FROM SQUARE TO ROUND... ... FROM ROUND TO SQUARE....OR...

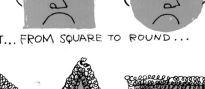 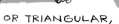

...... DIAMOND, OR TRIANGULAR, OR ANY OTHER SHAPE YOU CAN THINK OF.

★ YOU CAN CHANGE THE NOSE FROM ONE FACE TO ANOTHER. ★YOU CAN CHANGE THE HAIR FROM ONE FACE TO ANOTHER.

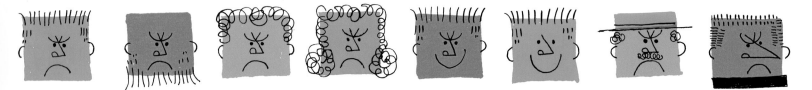

★ MOVING, SWAPPING, ADDING AND SUBTRACTING PARTS ARE ALL WAYS OF MAKING "NEW THINGS".

★ MORE NOTES AND HINTS:

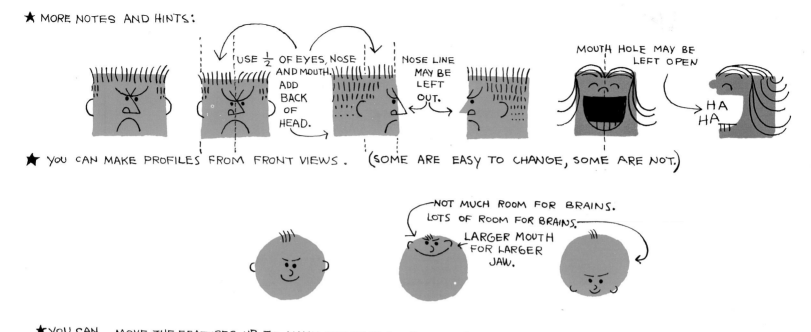

USE ½ OF EYES, NOSE AND MOUTH. ADD BACK OF HEAD.

NOSE LINE MAY BE LEFT OUT.

MOUTH HOLE MAY BE LEFT OPEN

HA HA

★ YOU CAN MAKE PROFILES FROM FRONT VIEWS. (SOME ARE EASY TO CHANGE, SOME ARE NOT.)

NOT MUCH ROOM FOR BRAINS.
LOTS OF ROOM FOR BRAINS.
LARGER MOUTH FOR LARGER JAW.

★ YOU CAN MOVE THE FEATURES UP TO MAKE THE FACE LOOK TOUGH OR DUMB, OR DOWN TO DO THE OPPOSITE.

* NOTE THAT EARS MOVE DOWN AS EYES AND NOSE MOVE DOWN.

* NOTICE HEAD REMAINS THE SAME SIZE.

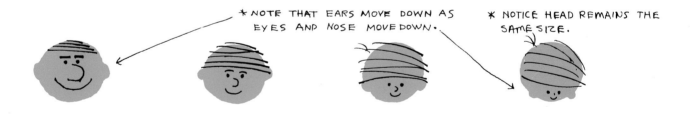

★ TO MAKE A FACE LOOK YOUNGER MAKE THE NOSE AND EYEBROWS SMALLER, ALSO MOVE THE FEATURES DOWN.

ADD FROM EARS DOWN.

← LIKE THIS. NOT THIS →

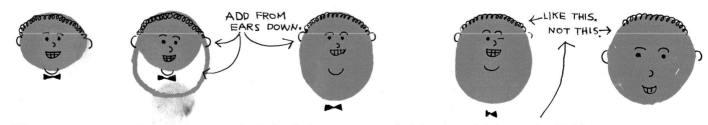

★ TO MAKE A FACE LOOK FAT - KEEP THE FEATURES SMALL, CLOSE TOGETHER AND HIGH ON THE FACE.

• HERE ARE SOME PARTS IN CASE YOU WOULD LIKE TO MAKE SOME FACES FROM SCRATCH.

NOSES

EYES

MOUTHS

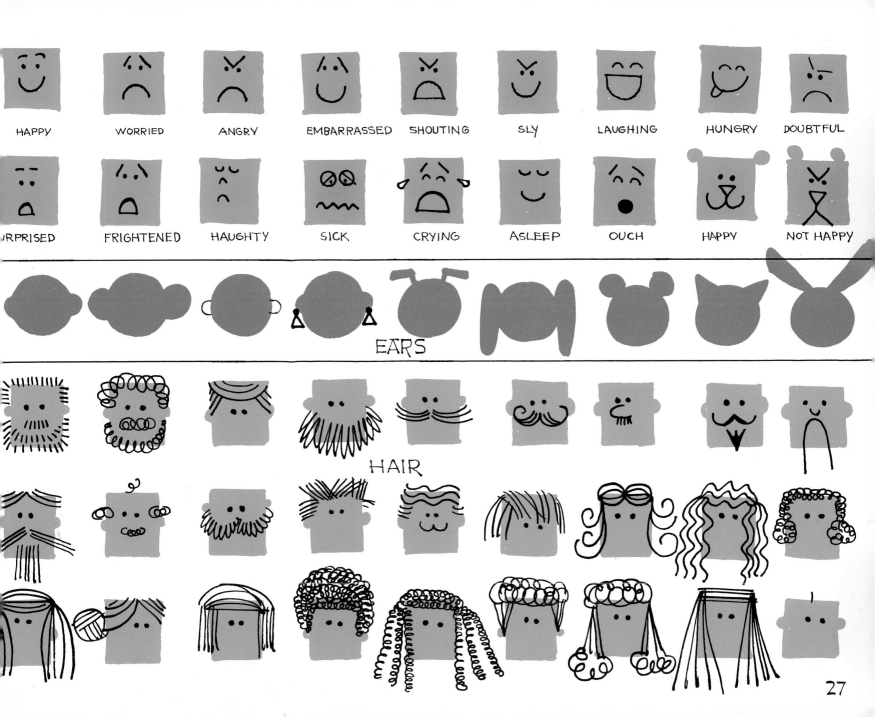

HAPPY WORRIED ANGRY EMBARRASSED SHOUTING SLY LAUGHING HUNGRY DOUBTFUL

URPRISED FRIGHTENED HAUGHTY SICK CRYING ASLEEP OUCH HAPPY NOT HAPPY

EARS

HAIR

27

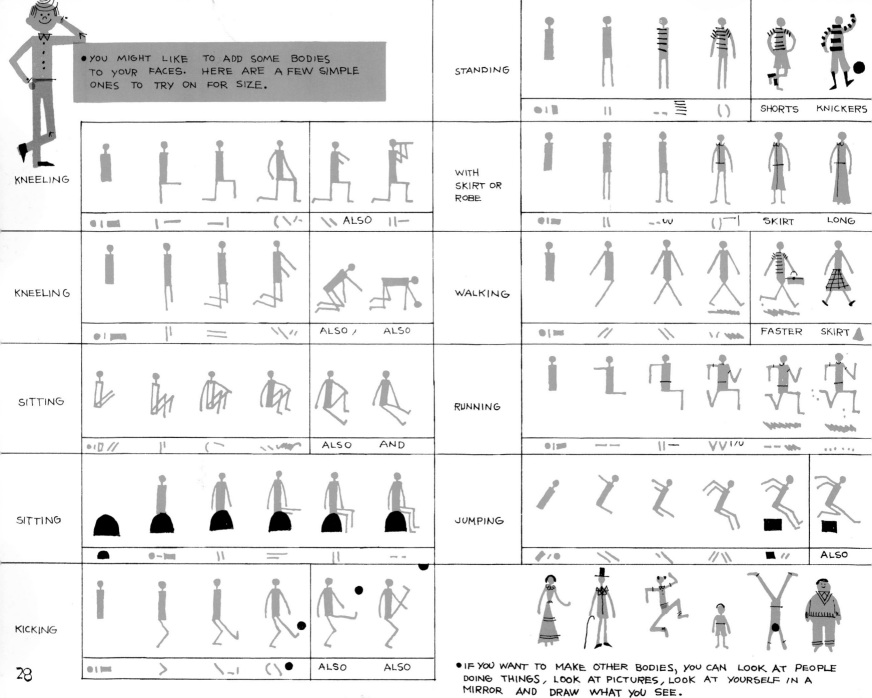

● YOU MIGHT LIKE TO ADD SOME BODIES TO YOUR FACES. HERE ARE A FEW SIMPLE ONES TO TRY ON FOR SIZE.

STANDING

SHORTS KNICKERS

KNEELING

ALSO

WITH SKIRT OR ROBE

SKIRT LONG

KNEELING

ALSO ALSO

WALKING

FASTER SKIRT

SITTING

ALSO AND

RUNNING

SITTING

JUMPING

ALSO

KICKING

ALSO ALSO

● IF YOU WANT TO MAKE OTHER BODIES, YOU CAN LOOK AT PEOPLE DOING THINGS, LOOK AT PICTURES, LOOK AT YOURSELF IN A MIRROR AND DRAW WHAT YOU SEE.

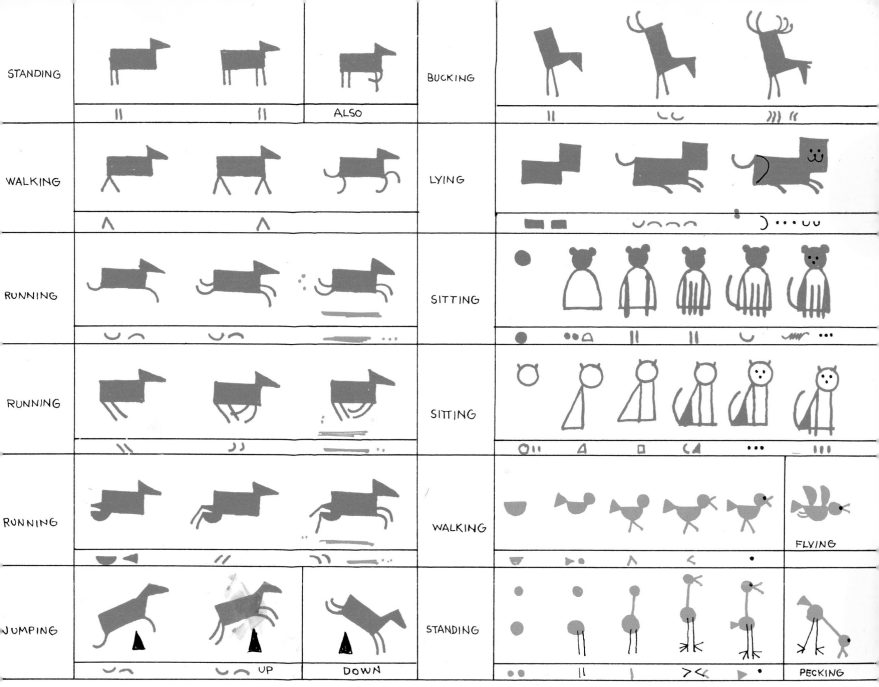

STANDING			ALSO	BUCKING	
WALKING				LYING	
RUNNING				SITTING	
RUNNING				SITTING	
RUNNING				WALKING	FLYING
JUMPING		UP	DOWN	STANDING	PECKING

29

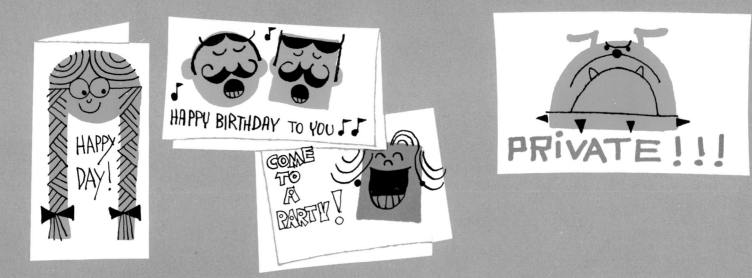

YOU CAN USE FACES TO MAKE ALL KINDS OF GOOD STUFF, SUCH AS:

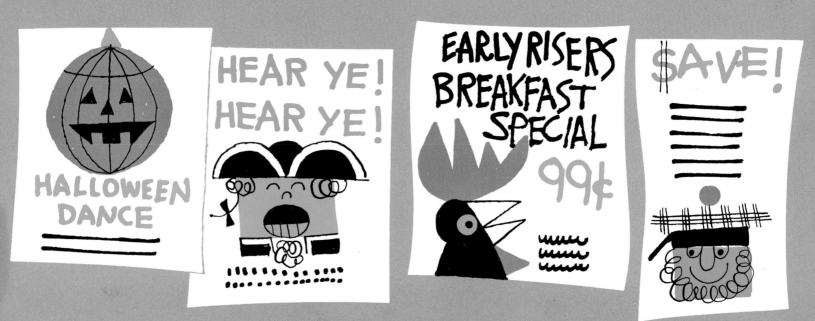

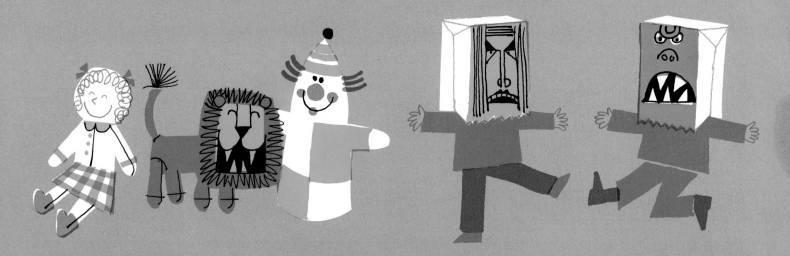

CARDS, . SIGNS, POSTERS, LETTERS, MASKS, PUPPETS, AND DOLLS .

WHAT'S COOKING ?

GUESS WHAT?

WE ALL MISS YOU.

COPYING IS ONE WAY TO LEARN HOW TO DRAW.
I HOPE YOU ENJOY TRYING TO DRAW "MY WAY,"
WILL CONTINUE TO DRAW "YOUR WAY"
AND KEEP LOOKING FOR NEW WAYS.

Ed Emberley

HAPPY DRAWING!

·INDEX·

* FACES STARRED CAN BE
CHANGED FROM MALE TO
FEMALE OR VICE VERSA
BY MERELY CHANGING
THE NAME. FOR INSTANCE,
"MARTIAN MARTIN" COULD
BE CHANGED TO
MARTIAN MARCIA.